Nature's Inspirations

*Top 25 Paintings
paired with
Favorite Inspirational Quotes*

Featuring
Abstract Nature Paintings
by Holly Van Hart

Awarded
Grand Prize, California Statewide Painting Competition
and
Best of Houzz

hollyvanhart.com
holly@hollyvanhart.com
(650) 646 5590

Titles of Paintings and Authors of Quotes

Summer Sparkle

Woodland Symphony

Forest Reverie

You're Invited

The Grand Escape

Color Me Free

Wandering in Wonder

The Secrets Within

Alternate Reality

Foggy Morning

Autumn Gold

Autumn Reds

Into the Light

Field of Dreams

Dreaming in Full Color

How Dreams Are Made

Amid the Scent of Roses

A Full Life

Rose Jamboree

Your Highest Potential

Celebration

Unlimited Possibilities

Flush with Possibilities

Nest at Night

Possibilities Abound

Dream Weaver

Soft Start

Outside My Window

Serenity

+ Popping, Blooms Abounding, and Fresh Adventure

Walt Disney

Frank Lloyd Wright

Elizabeth Gilbert

Henry Ford

Anthony J. D'Angelo

Carol S. Dweck

John Muir

Sara Blakely

Ayn Rand

Alice Walker

Marie Forleo

Thomas Edison

Beyoncé Knowles

Mother Teresa

Shonda Rhimes

Arianna Huffington

Sheryl Sandberg

H. Jackson Brown, Jr.

Gordon Parks

Barbara Corcoran

J.K. Rowling

Albert Einstein

Erica Jong

Vincent Van Gogh

Nora Ephron

Eleanor Roosevelt

Hello!

Do you believe in limitless opportunities?

I do.

Sure, constraints will pop up here and there, but for the most part if we can dream it, we can make it true.

This is the theme of my art and this book. I am a visual artist, and this book shows images of my abstracted nature paintings paired with favorite inspirational quotes.

My paintings are meant to spark new excitement about the limitless opportunities we have in our lives.

Enjoy!

All our dreams can come true, if we have the courage to pursue them.

Walt Disney

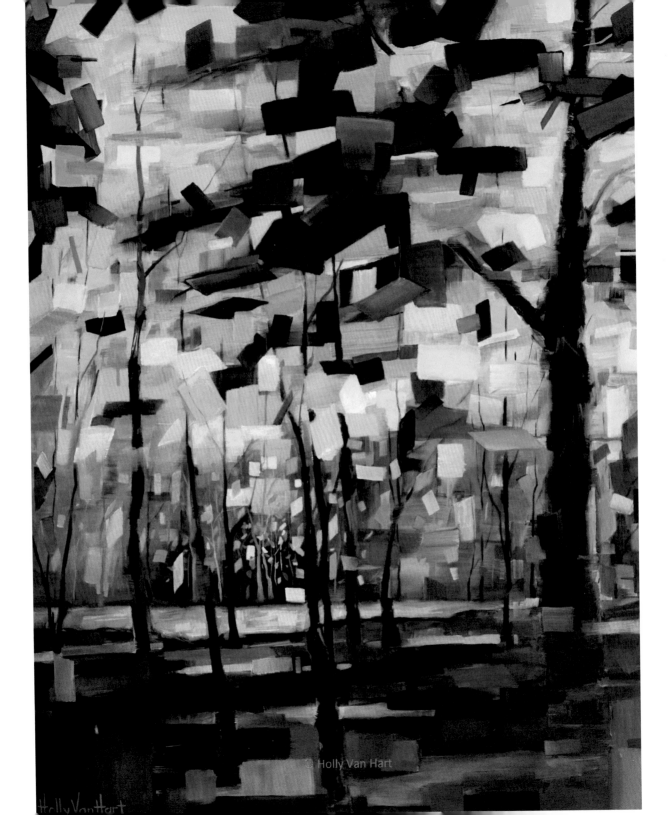

Holly Van Hart

Study nature, love nature, stay close to nature. It will never fail you.

Frank Lloyd Wright

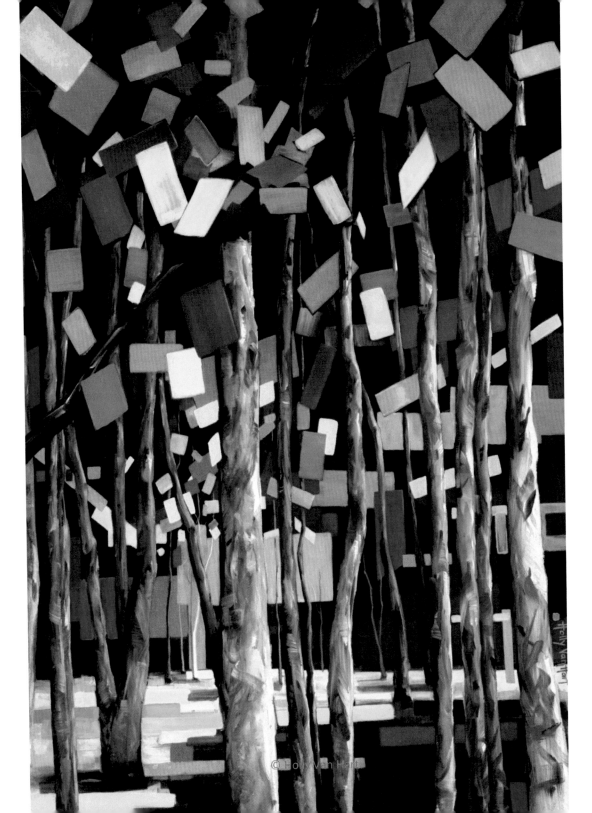

Do whatever brings you to life, then. Follow your own fascinations, obsessions, and compulsions.

Elizabeth Gilbert

Image: **Forest Reverie,** Oil and acrylic painting by Holly Van Hart, 48 x 36 inches

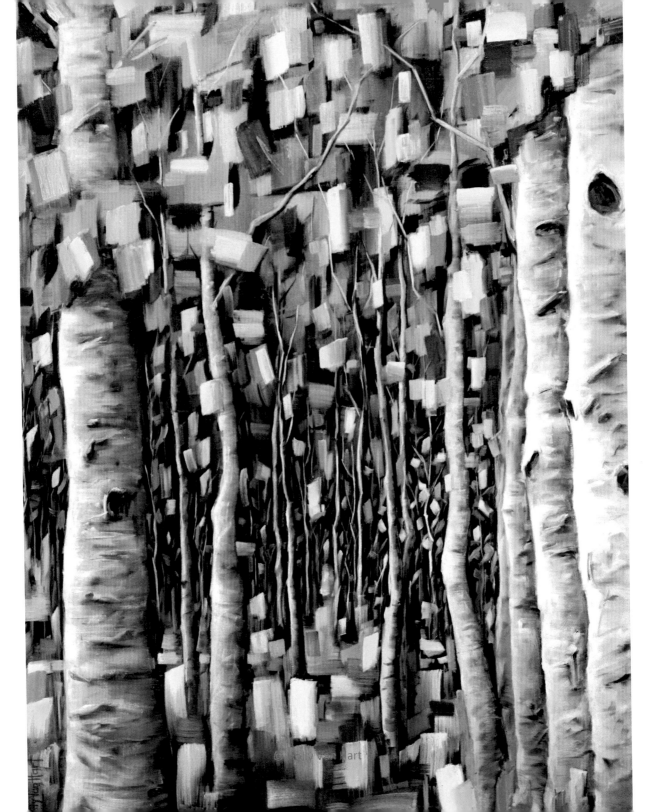

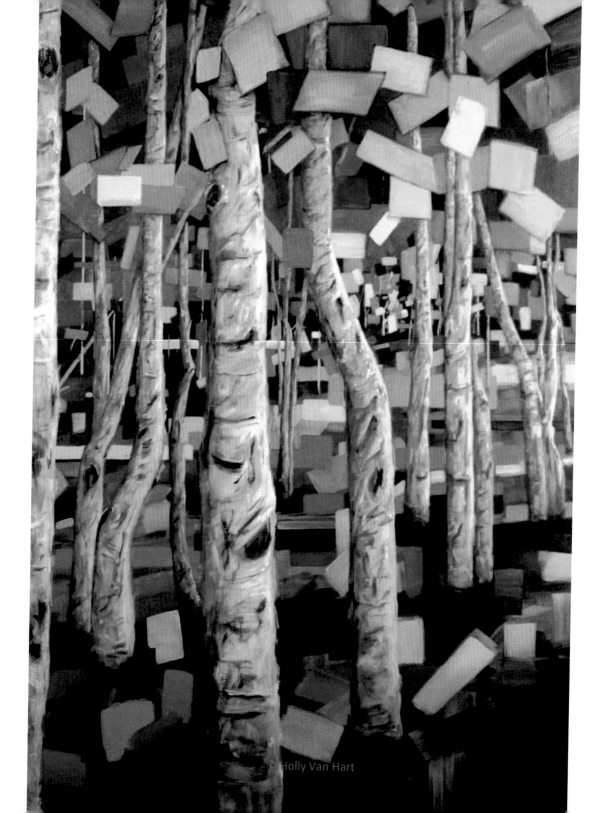

Whether you think you can or think you can't, you're right.

Henry Ford

Wherever you go,
no matter what the weather,
always bring your own sunshine.

Anthony J. D'Angelo

Image: **The Grand Escape,** Oil and acrylic painting by Holly Van Hart, 30 x 40 inches

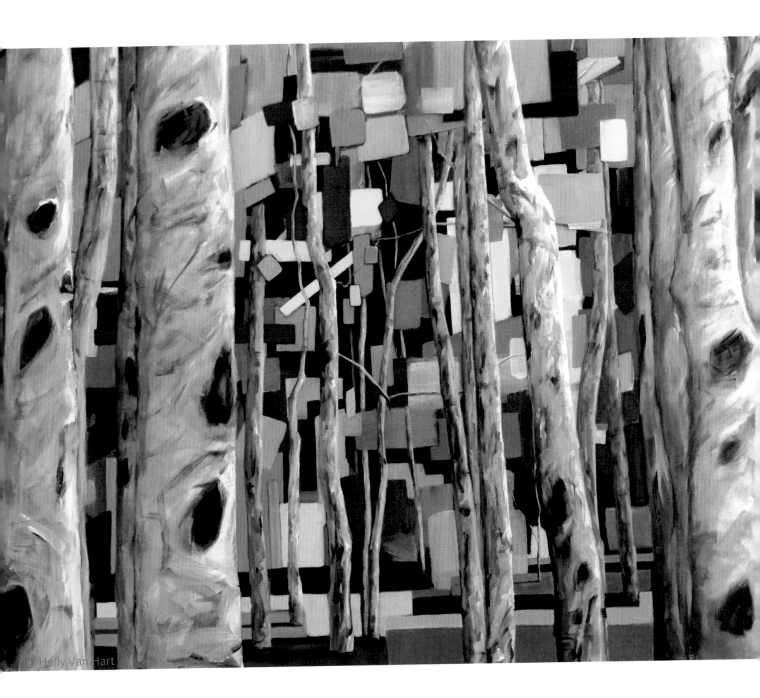

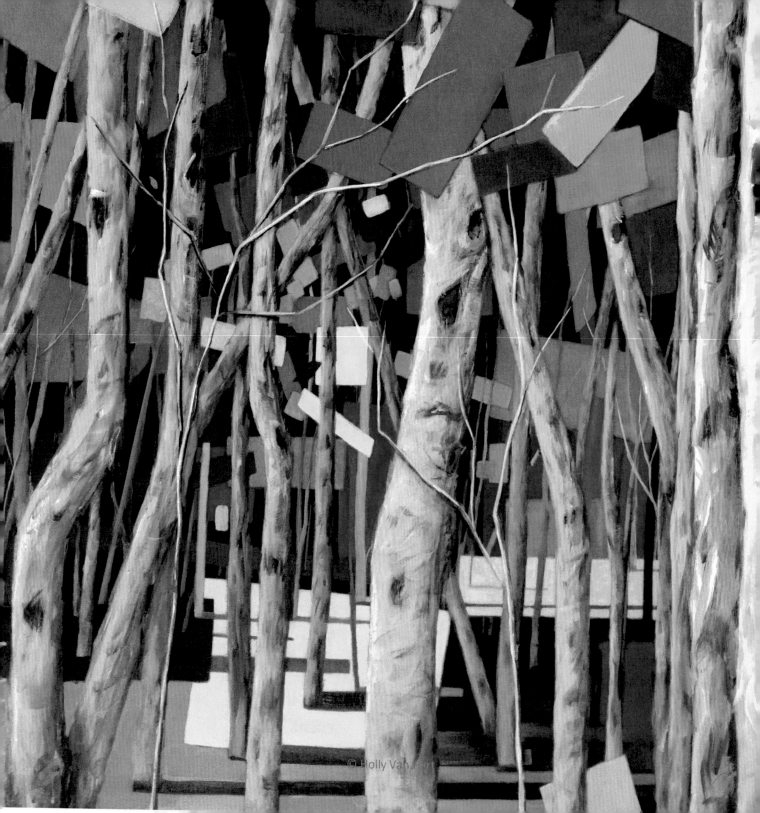

You have to work hardest
for the things you love the most.

Carol S. Dweck

Image: **Color Me Free,** Oil and acrylic painting by Holly Van Hart, 30 x 24 inches

In every walk with nature, one receives far more than he seeks.

John Muir

Image: **Wandering in Wonder,** Oil and acrylic painting by Holly Van Hart, 48 x 60 inches

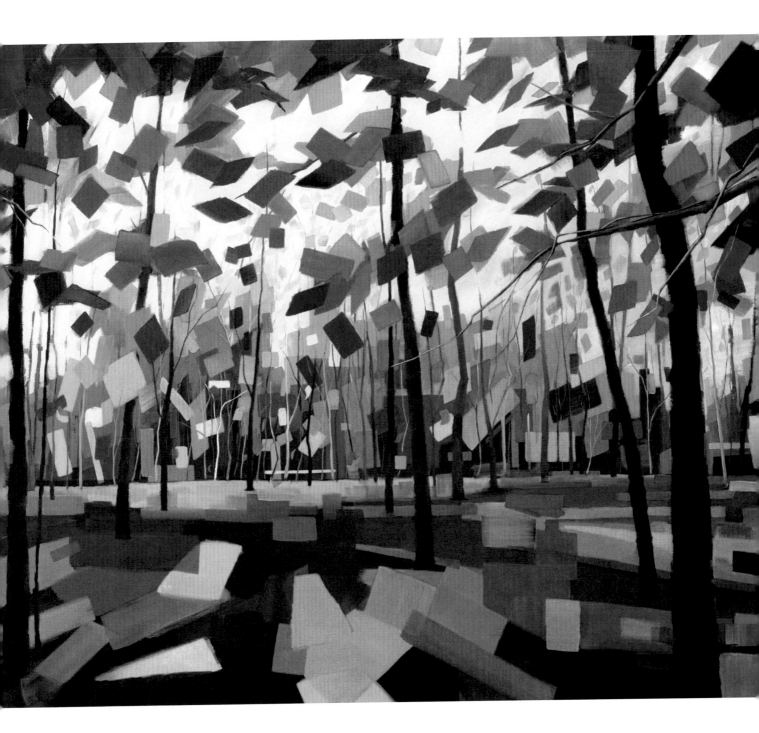

Courage
is doing something
despite the fear.

Sara Blakely

Image: **The Secrets Within,** Oil and acrylic painting by Holly Van Hart, 40 x 30 inches

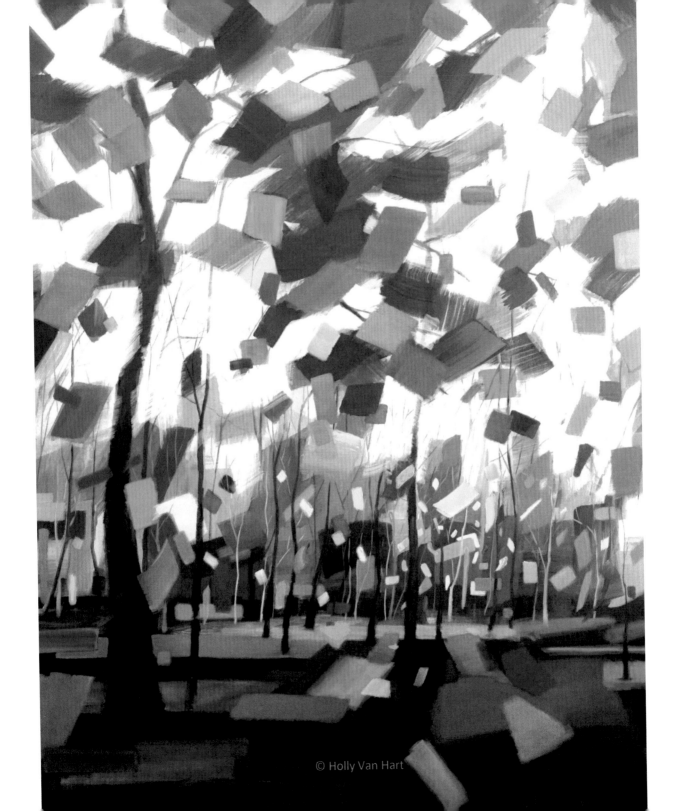

© Holly Van Hart

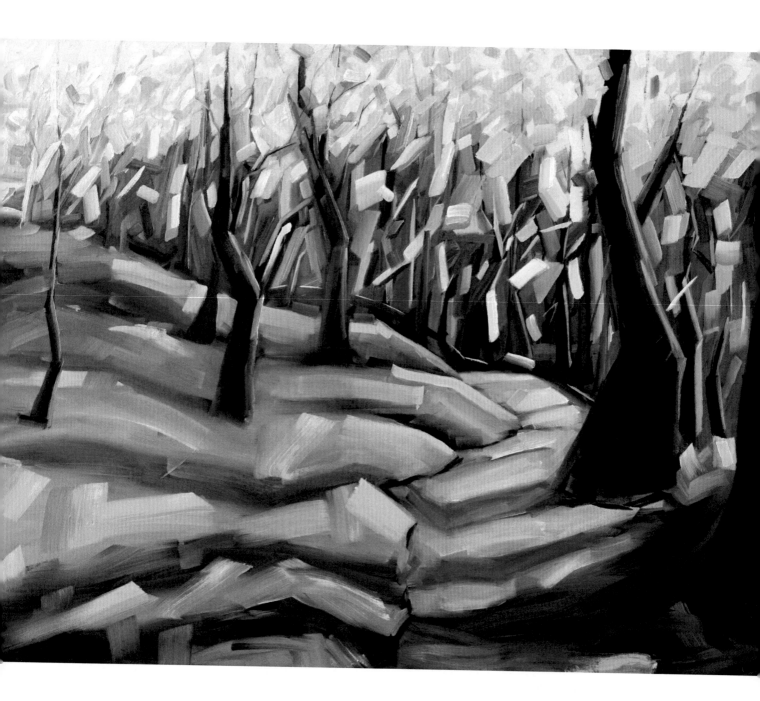

The question isn't who is going to let me; it's who is going to stop me.

Ayn Rand

In nature,
nothing is perfect and
everything is perfect.

Alice Walker

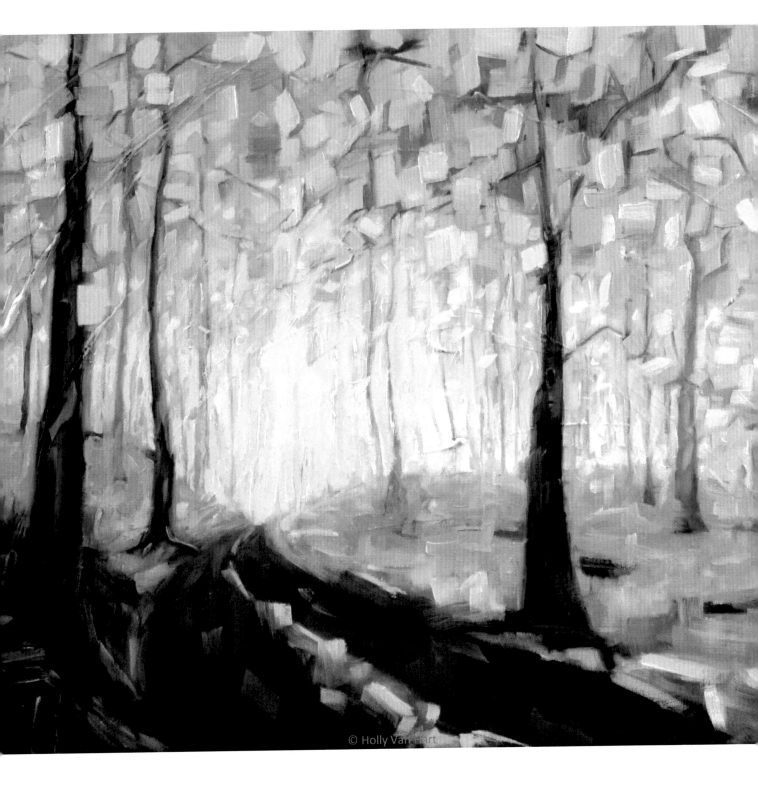

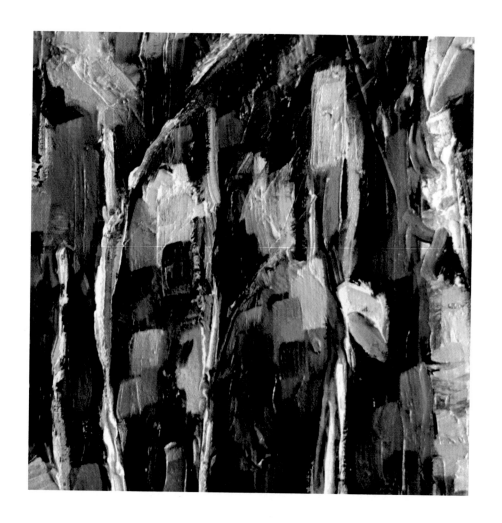

Image: **Autumn Gold,** Oil painting by Holly Van Hart, 24 x 18 inches

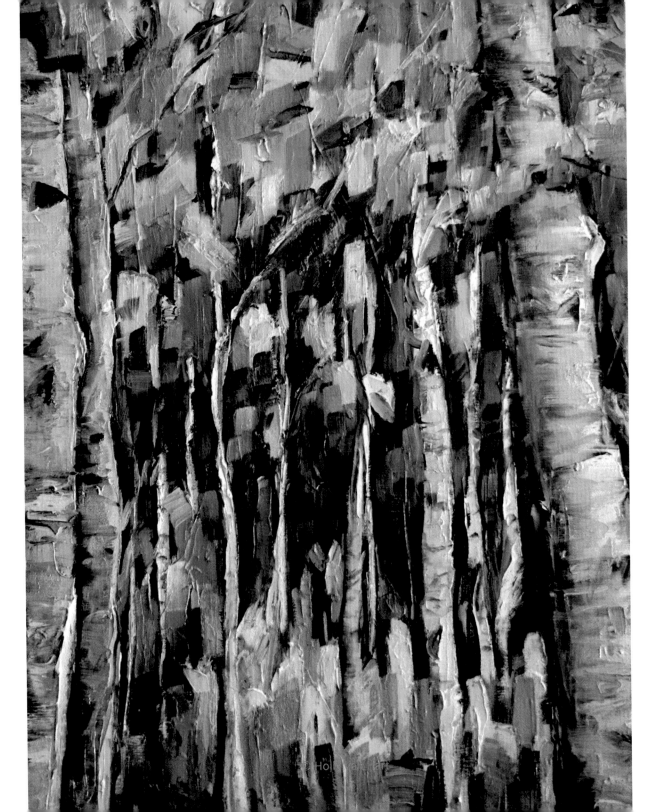

The key to success
is to
start before you're ready.

Marie Forleo

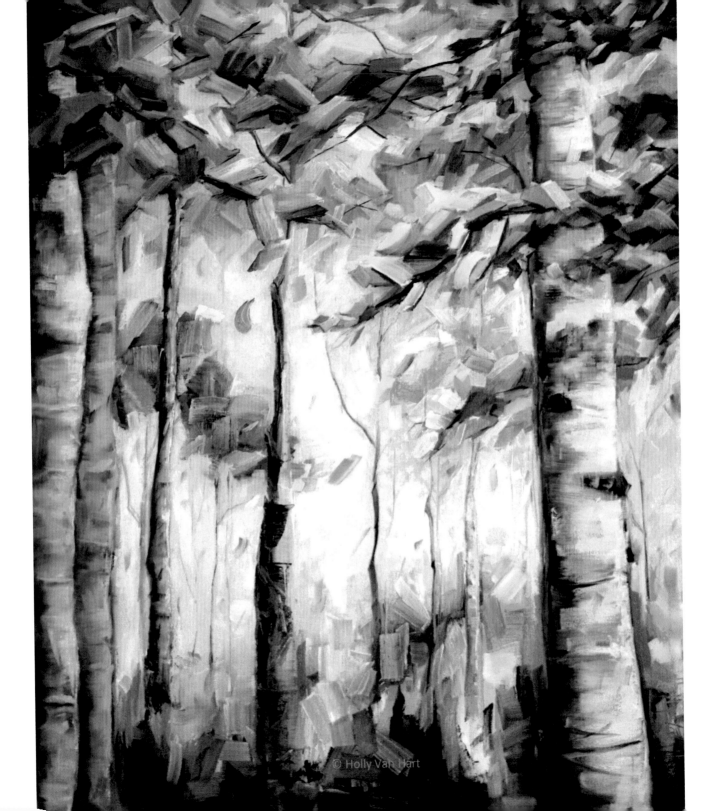

When you have exhausted all the possibilities, remember this; you haven't.

Thomas Edison

Image: **Into the Light,** Oil and acrylic painting by Holly Van Hart, 24 x 30 inches

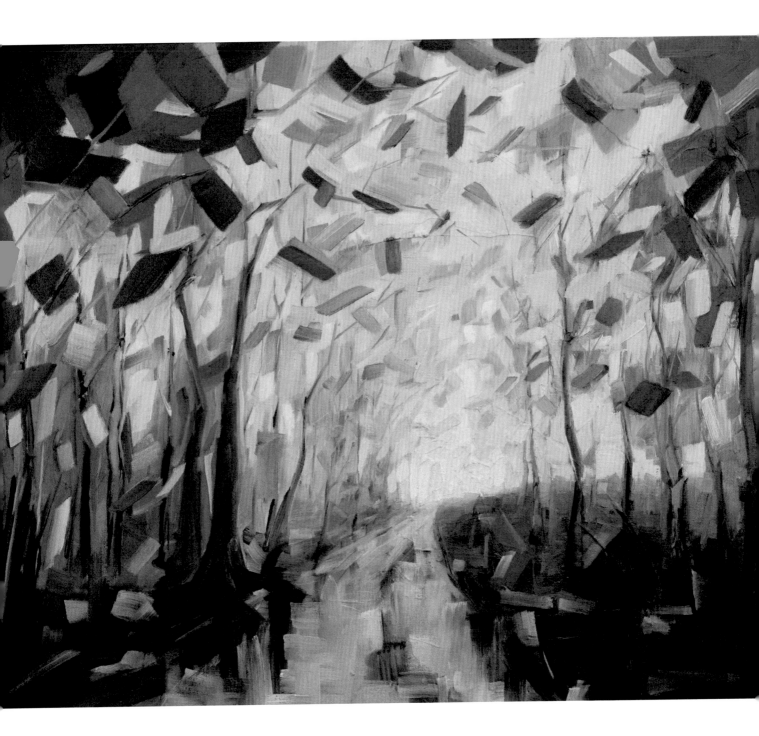

Your self-worth
is
determined by you.

Beyoncé Knowles

Image: **Field of Dreams,** Oil and acrylic painting by Holly Van Hart, 24 x 30 inches

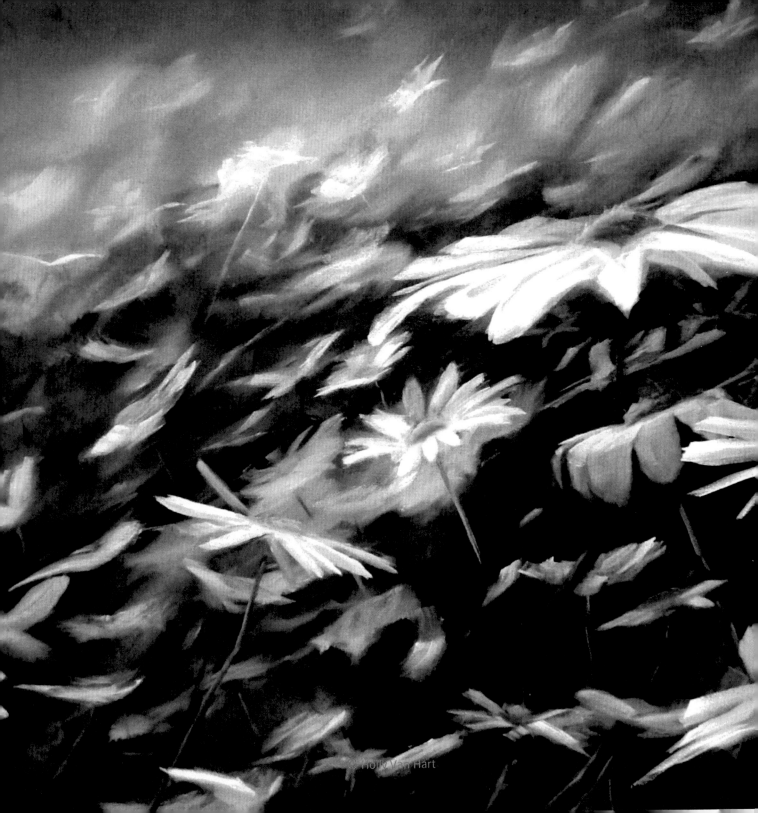

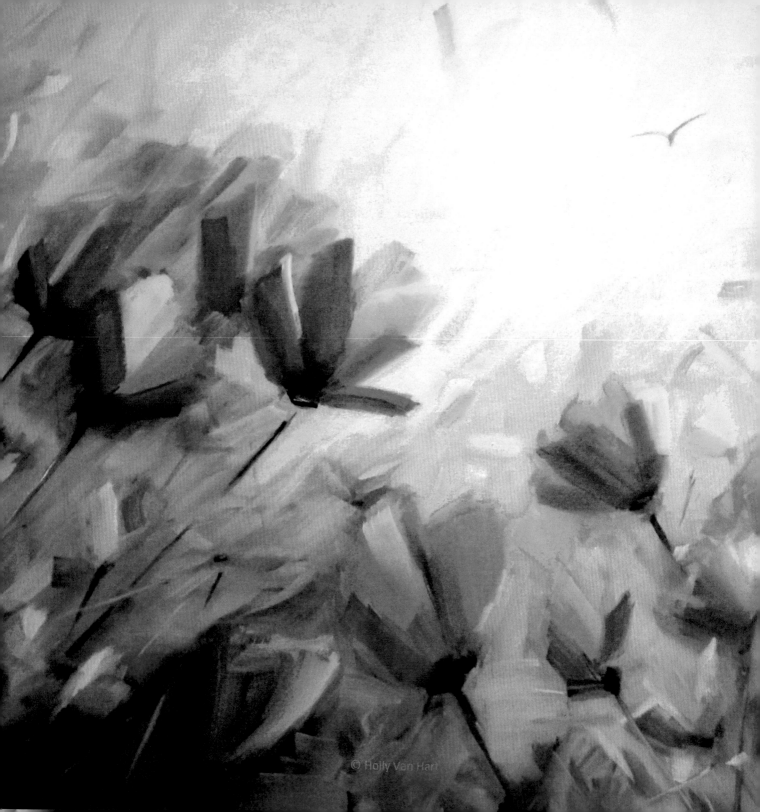

Spread love everywhere you go.

Mother Teresa

Image: **Dreaming in Full Color,** Oil painting by Holly Van Hart, 24 x 30 inches

Image: **How Dreams Are Made,** Oil and acrylic painting by Holly Van Hart, 36 x 48 inches

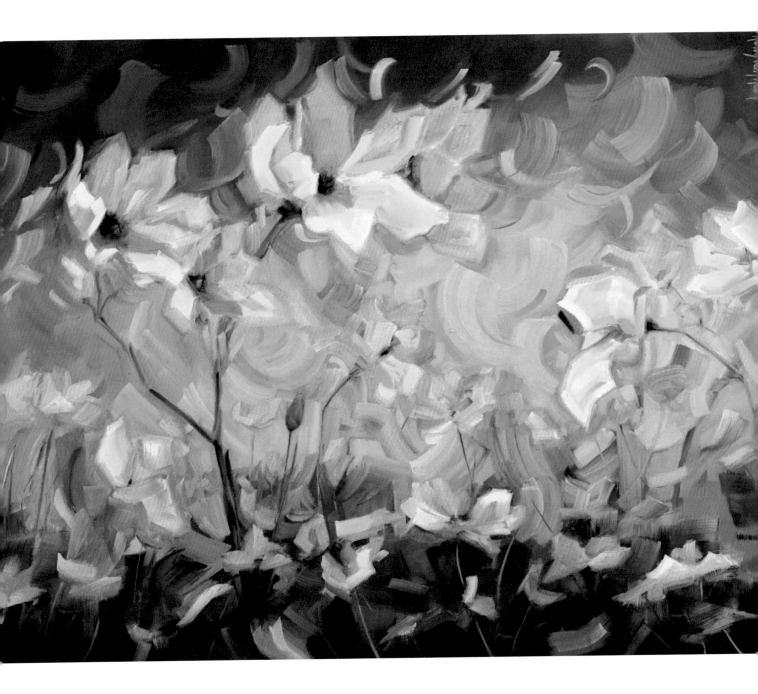

Cynicism is a choice.
Optimism is a better choice.

Shonda Rhimes

Image: **Amid the Scent of Roses,** Oil and acrylic painting by Holly Van Hart, 30 x 24 inches

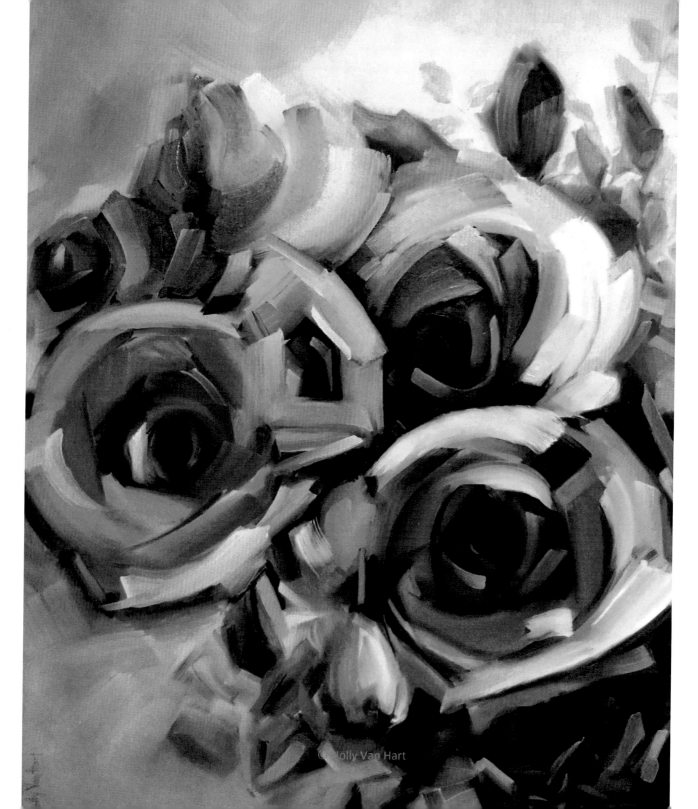

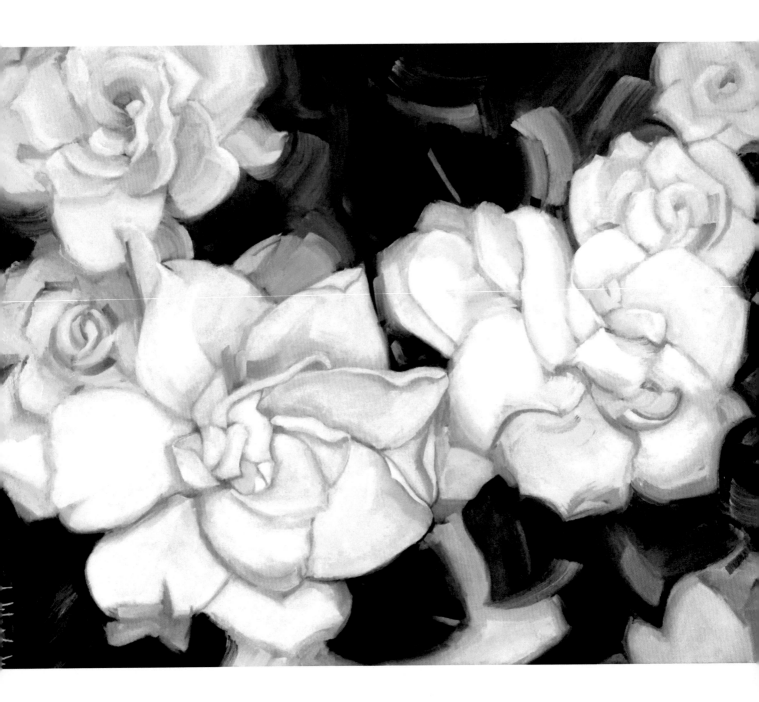

It's not
'What do I want to do?'
it's
'What kind of life
do I want to have?'

Arianna Huffington

Image: **A Full Life,** Oil painting by Holly Van Hart, 30 x 40 inches

If you're offered a seat on a rocket ship, don't ask what seat! Just get on.

Sheryl Sandberg

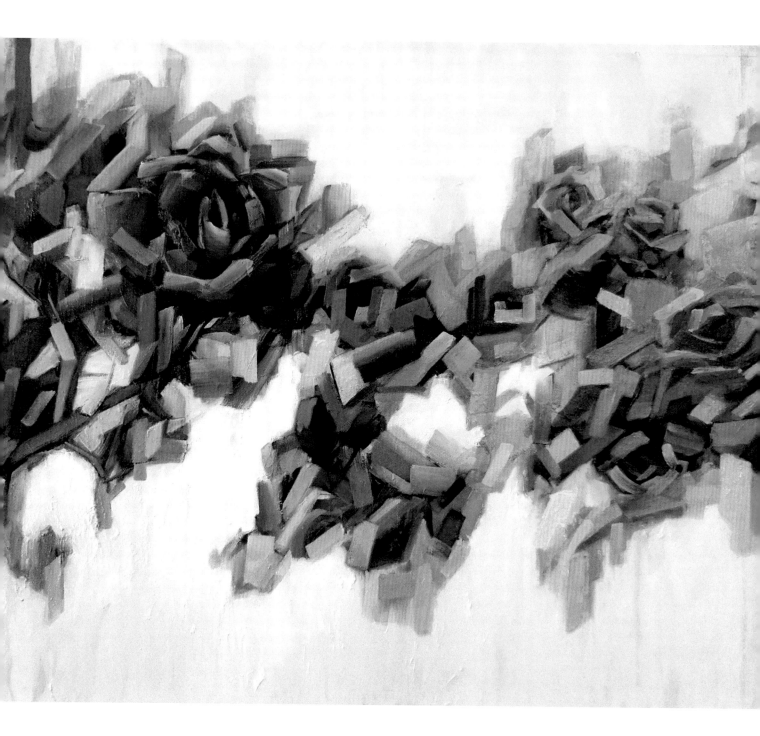

Opportunity dances with those already on the dance floor.

H. Jackson Brown, Jr.

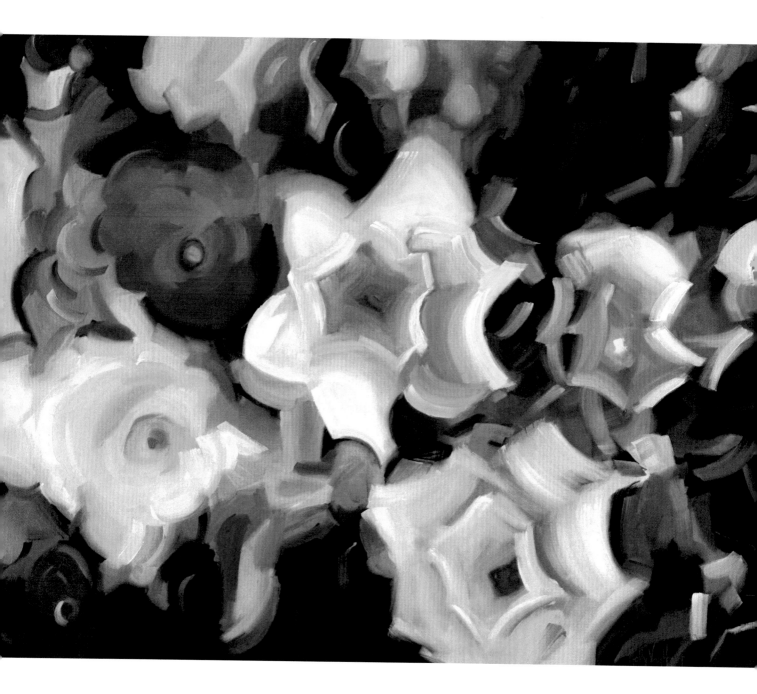

Enthusiasm
is the
electricity of life.

Gordon Parks

Image: **Celebration,** Oil and acrylic painting by Holly Van Hart, 54 x 72 inches

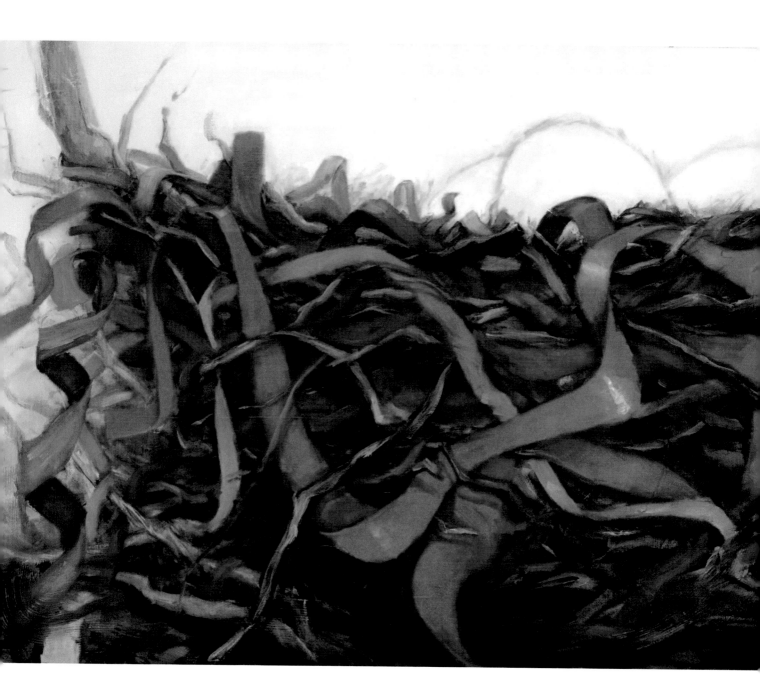

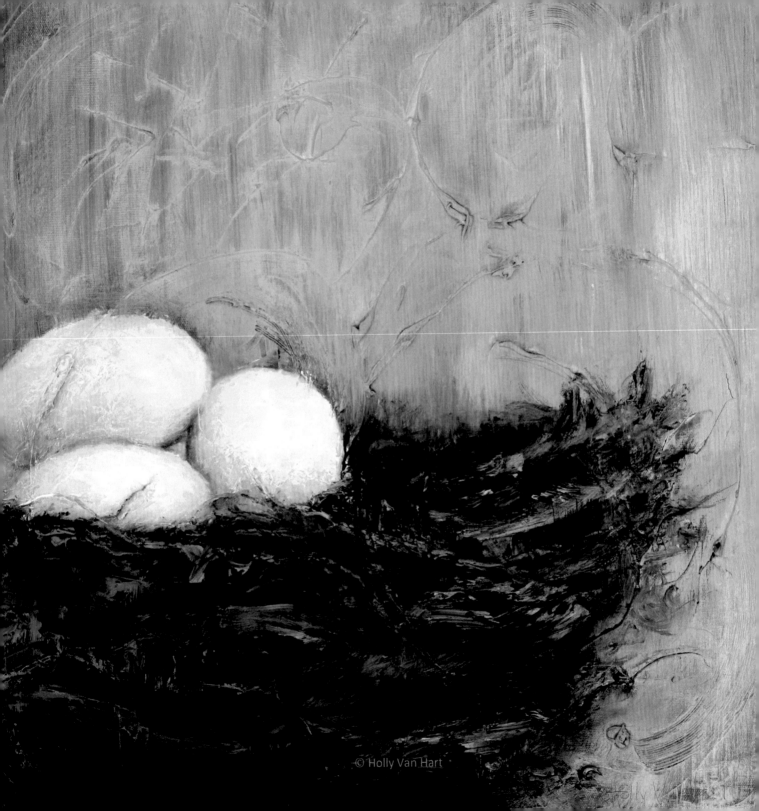

Finding opportunity is a matter of believing it's there.

Barbara Corcoran

Image: **Unlimited Possibilities,** Oil painting by Holly Van Hart, 20 x 20 inches

It is our choices,
that show what we truly are,
far more than our abilities.

J.K. Rowling

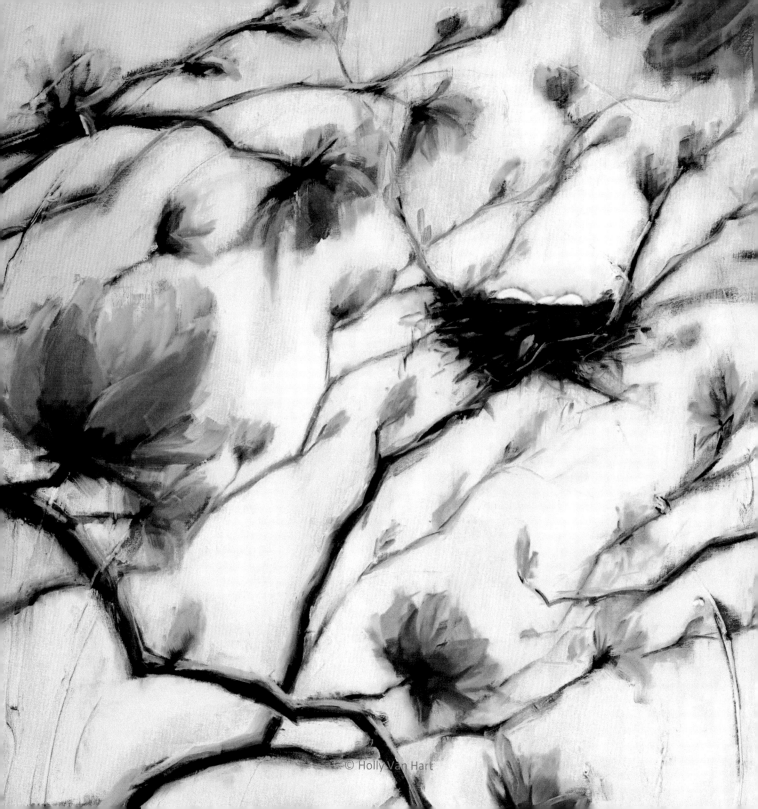

Look deep into nature, and then you will understand everything better.

Albert Einstein

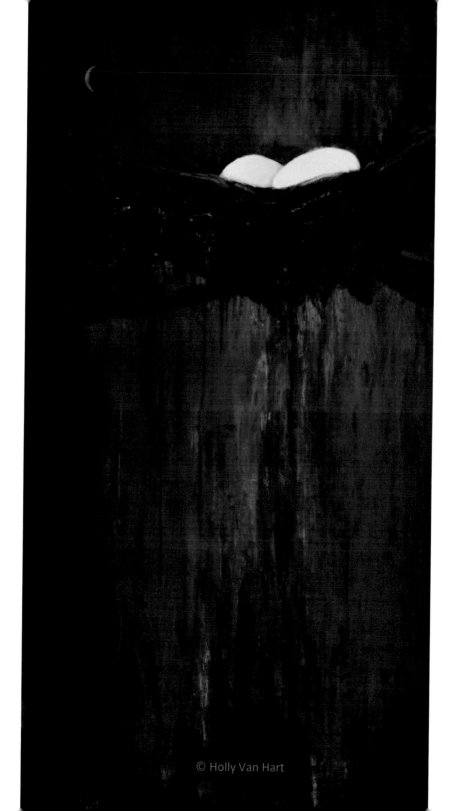

If you don't risk anything, you risk even more.

Erica Jong

Image: **Possibilities Abound**
Grand Prize, California Statewide Painting Competition
Oil painting by Holly Van Hart, 30 x 40 inches

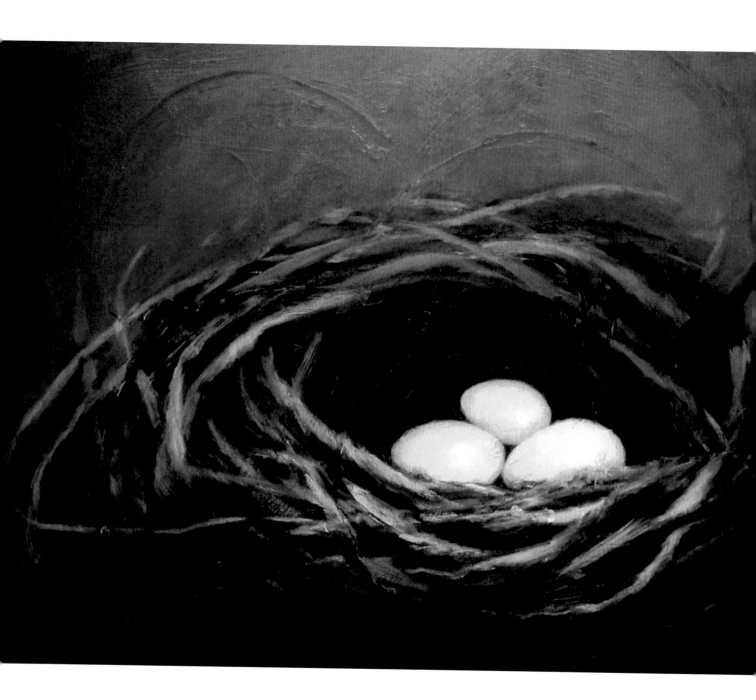

I dream of painting
and then I paint my dream.

Vincent Van Gogh

Image: **Dream Weaver,** Oil and acrylic painting by Holly Van Hart, 40 x 30 inches

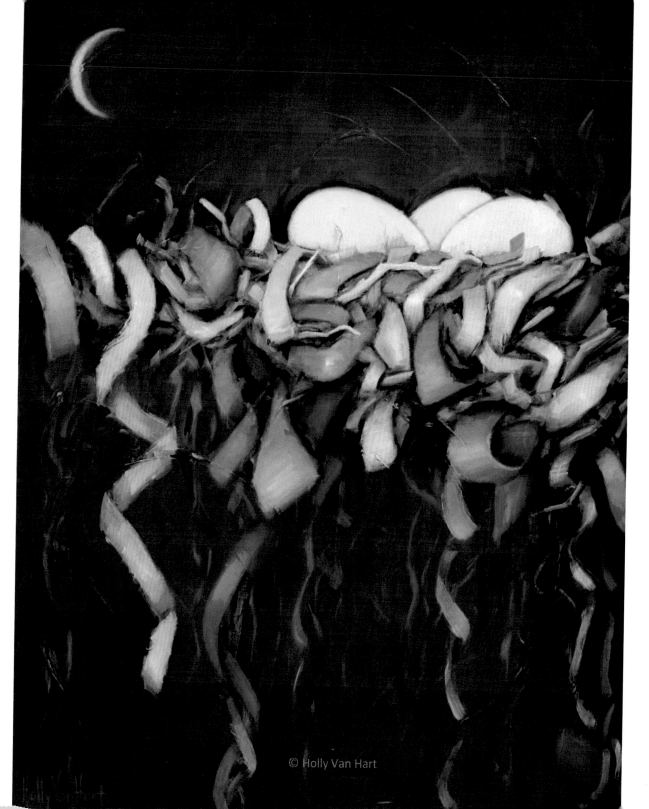

Image: **Soft Start,** Oil painting by Holly Van Hart, 30 x 40 inches

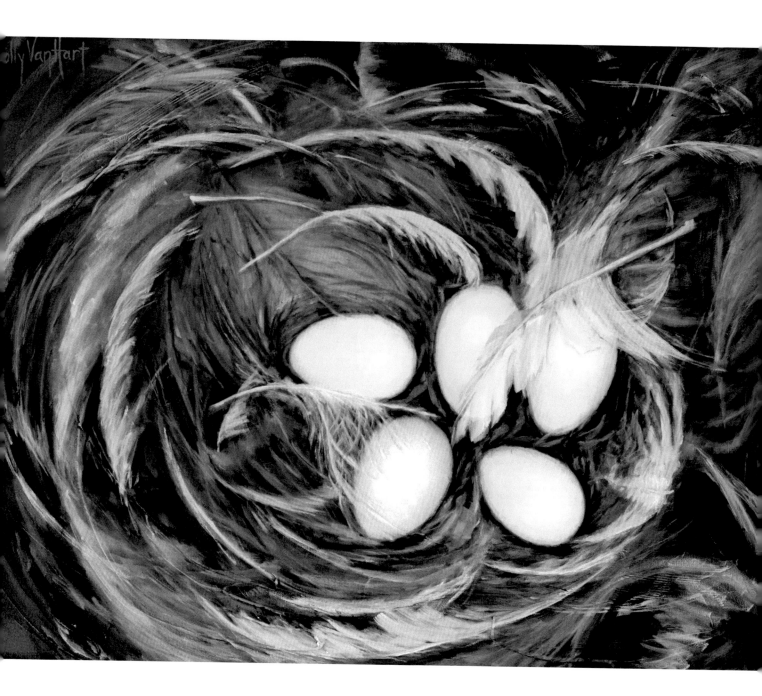

Above all,
be the heroine of your life.

Nora Ephron

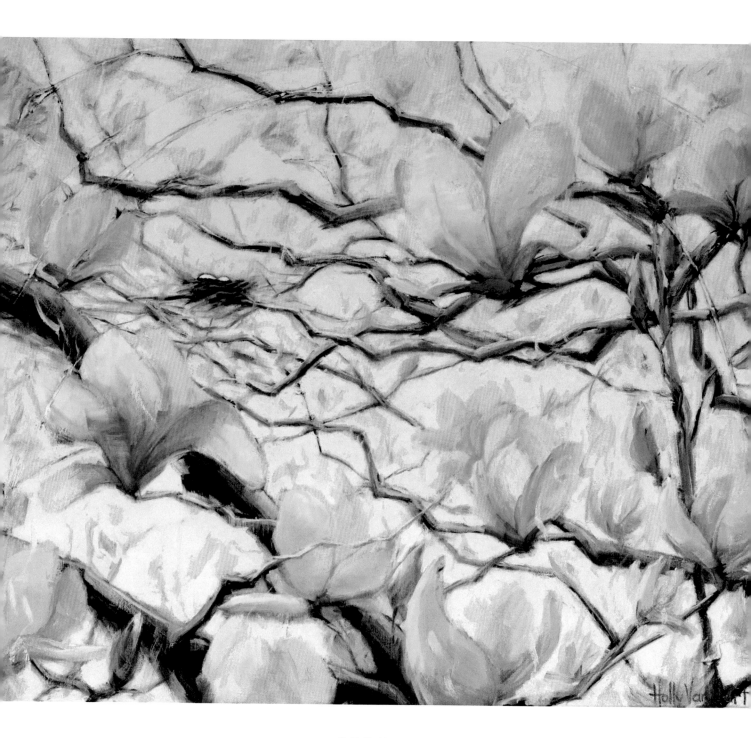

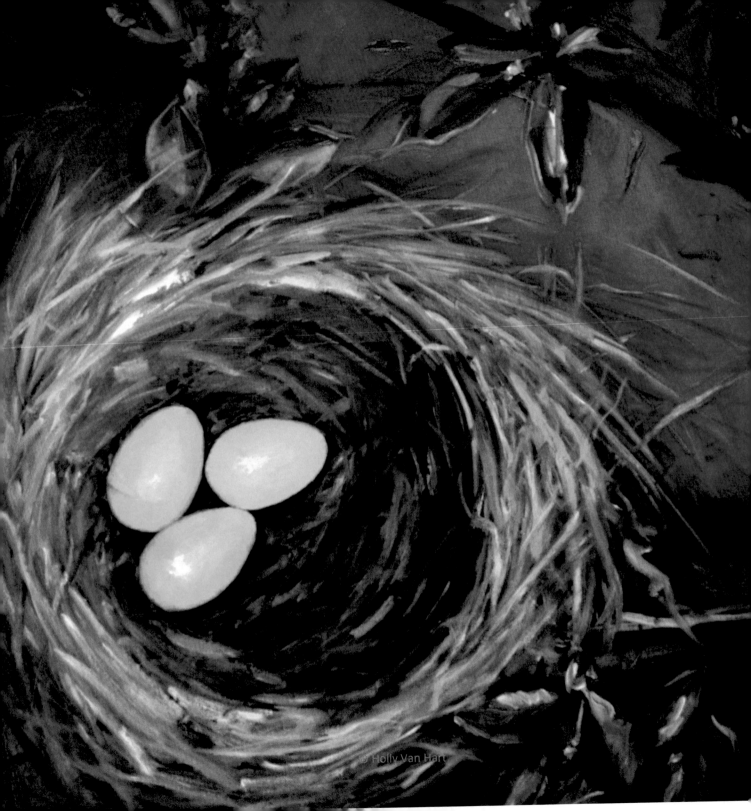

© Holly Van Hart

The future belongs to those who believe in the beauty of their dreams.

Eleanor Roosevelt

Image: **Serenity,** Oil painting by Holly Van Hart, 20 x 20 inches

You're Invited
Oil painting by Holly Van Hart

Popping
Oil painting by Holly Van Hart

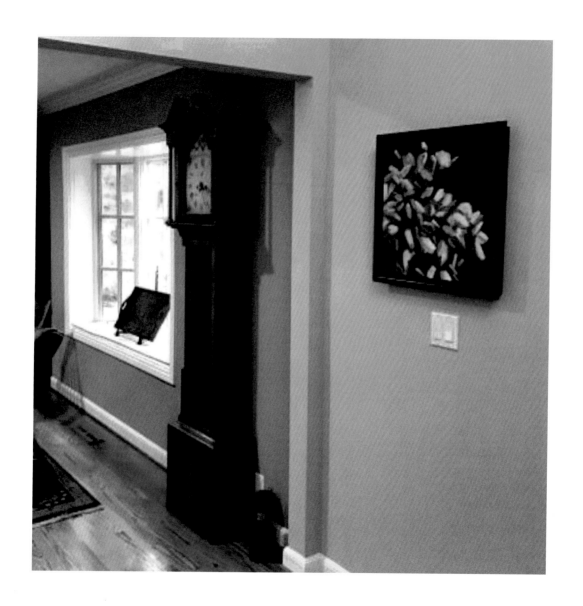

Blooms Abounding
Oil painting by Holly Van Hart

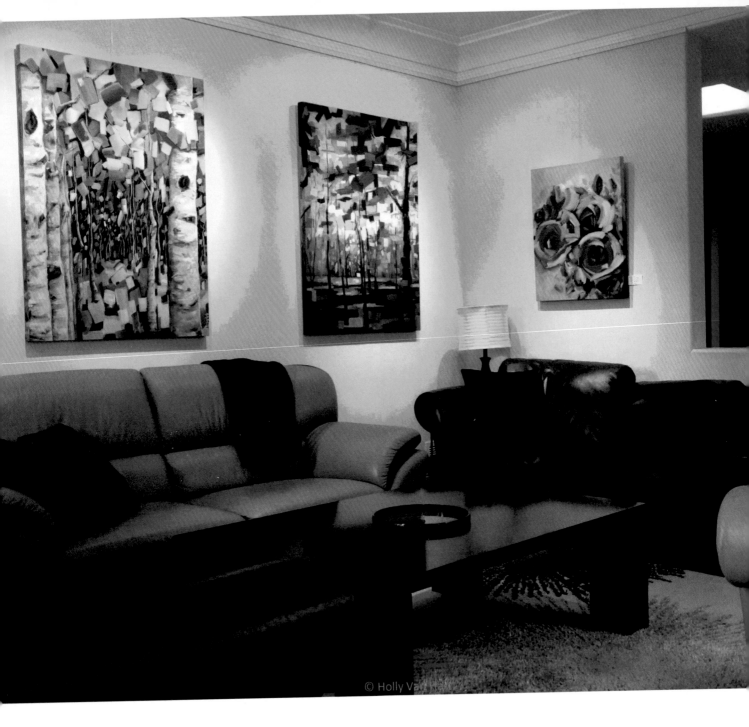

Autumn Dance, Summer Sparkle, and Amid the Scent of Roses
Oil and acrylic paintings by Holly Van Hart

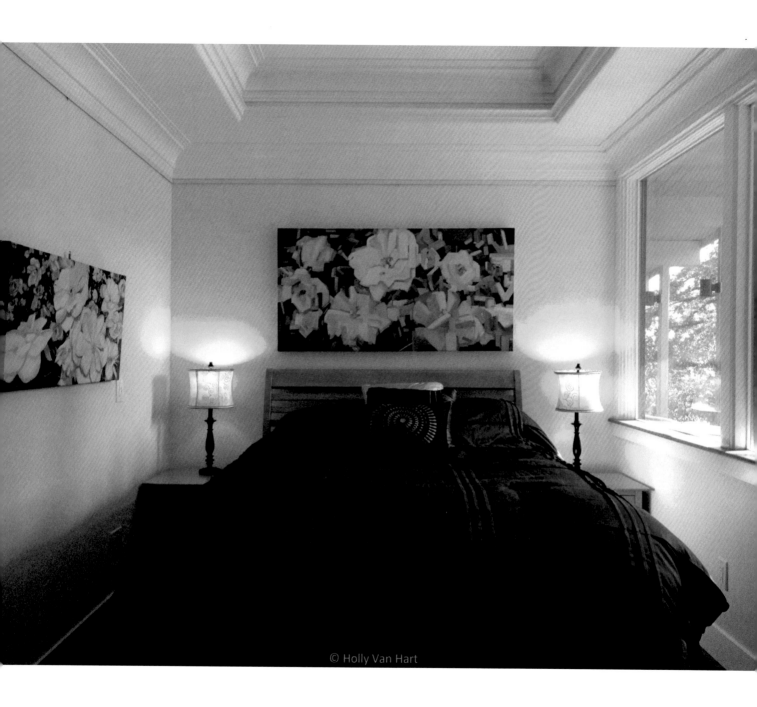

Fresh Adventure
Oil painting by Holly Van Hart

Artist Holly Van Hart

As featured in

THE
HUFFINGTON
POST

[**Silicon Valley**
'Talk Art' TV]

examiner.com

The Mercury News
The Newspaper of Silicon Valley
MercuryNews.com

*The future belongs to those who believe
in the beauty of their dreams.*
Eleanor Roosevelt

The future belongs to us.

Let's go get 'em!

Holly VanHart

holly@hollyvanhart.com
(650) 646 5590

For art and inspirations delivered to your inbox,

visit

http://hollyvanhart.com/vip

 Friend me here https://www.facebook.com/hollyvanhart

Made in the USA
San Bernardino, CA
03 February 2018